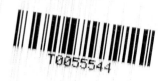

Beside the Slow Oak, 2009
Silkscreen on Simili Japon Paper
12" × 19"

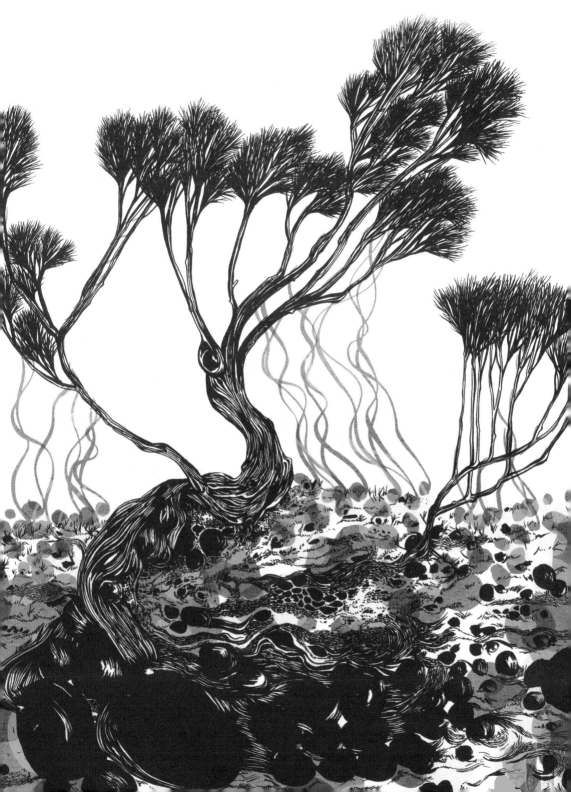

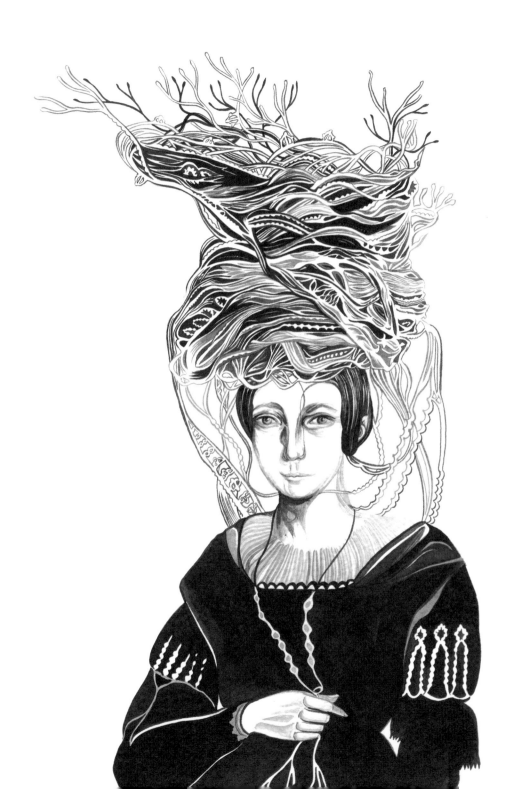

Untitled (Germination), 2009
Silkscreen on Simili Japon Paper
13" × 19"

Garlic & Sapphires in the Mud, 2010
Ink on Stonehenge Paper
15" × 19"

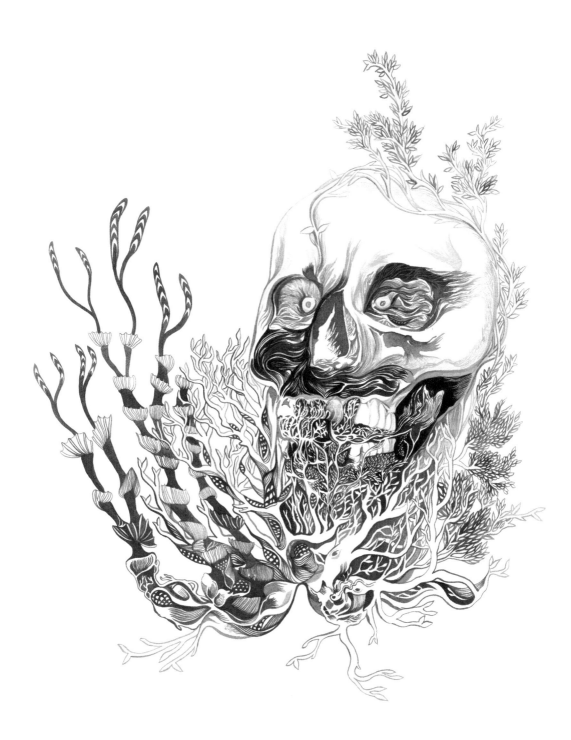

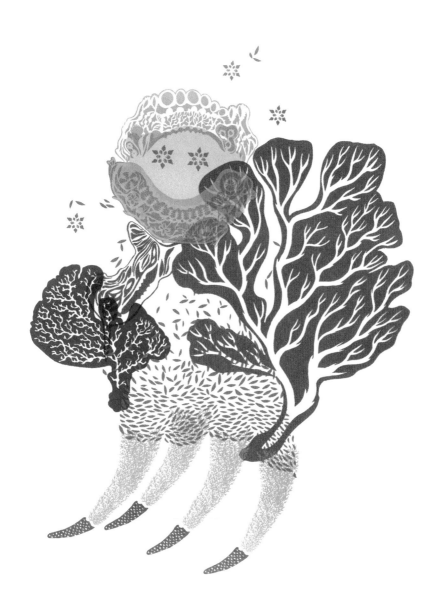

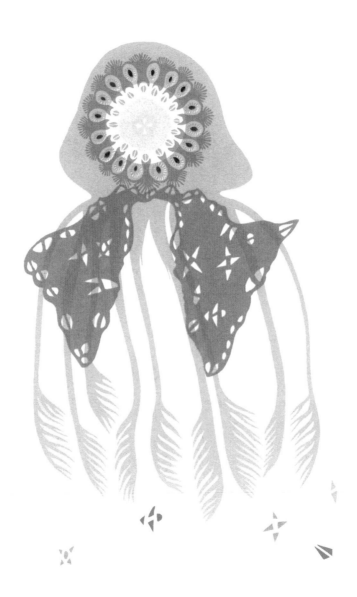

Untitled (Worlds), 2006
Silkscreen on BFK Rives Paper
13" × 11"

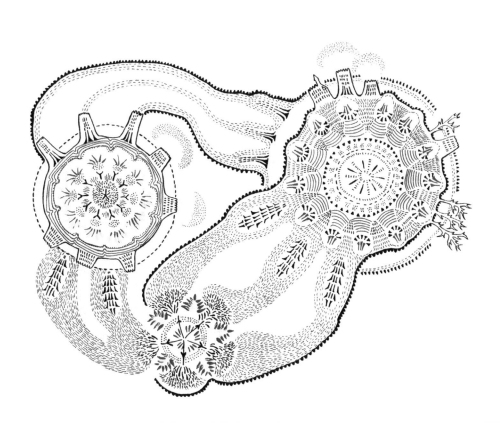

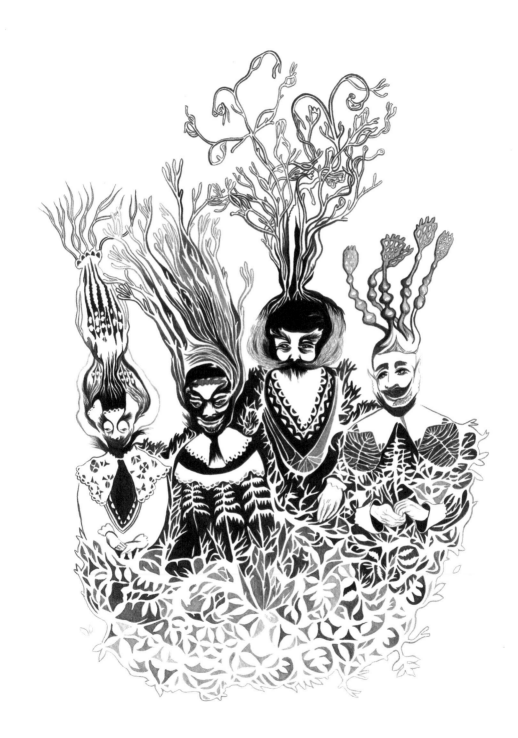

O Dark Dark Dark, 2010
Ink on Watercolour Paper
12.5" × 16"

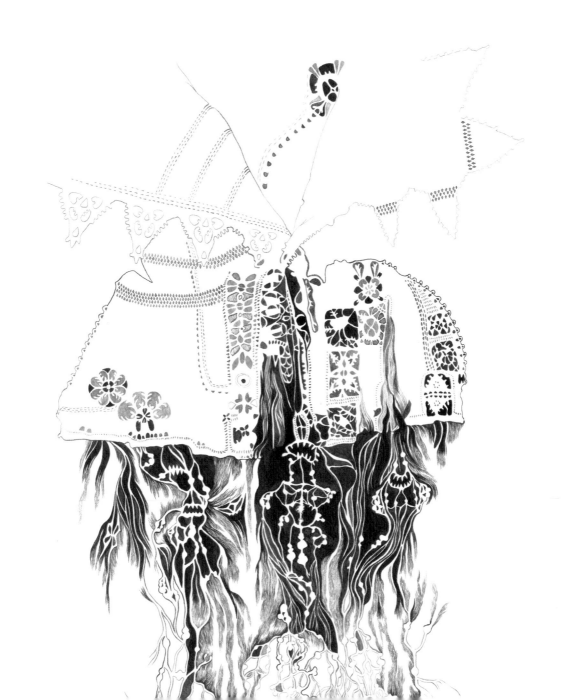

Into the Drained Pool, 2010
Ink on Watercolour Paper
12.5" × 16"

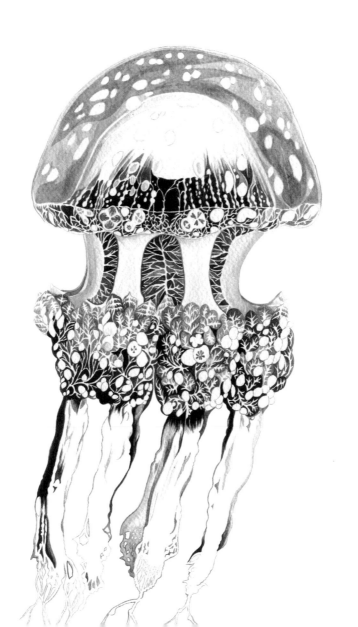

Untitled (Two Trees), 2011
Ink on Watercolour Paper
11.5" × 9"

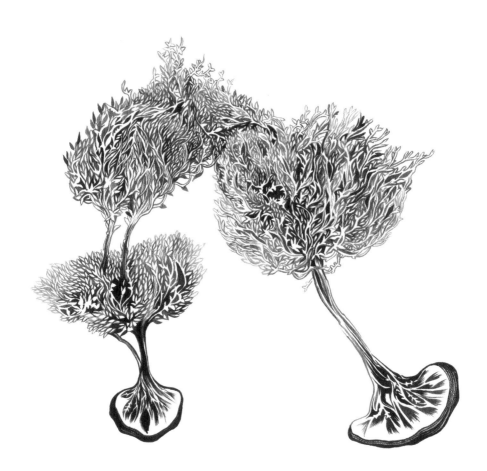

Home, From the Hill, 2009
Ink on Stonehenge Paper
22" × 15"

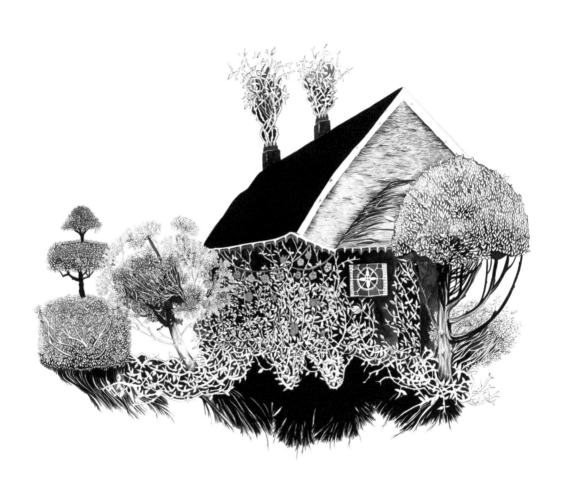

Eyrie, 2009
Ink on Stonehenge Paper
15" × 22"

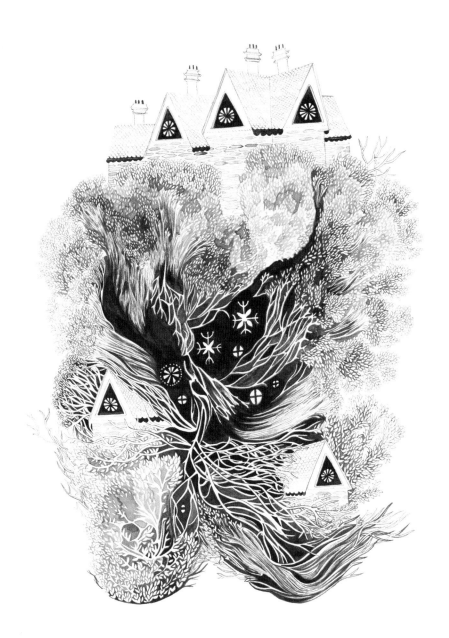

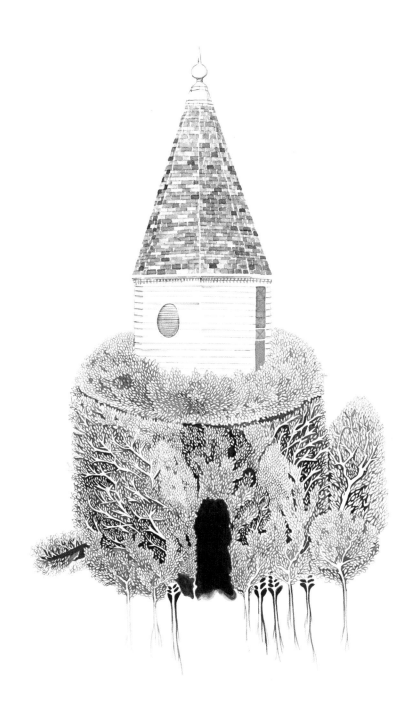

Euclidean Paradise, 2009
Ink on Stonehenge Paper
15" × 22"

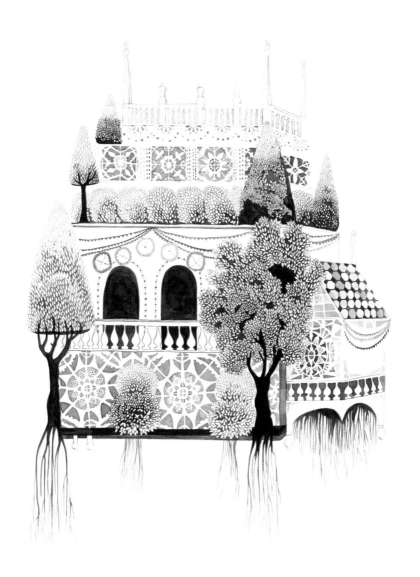

Darkling, I Listen, 2009
Ink on Stonehenge Paper
15" × 22"

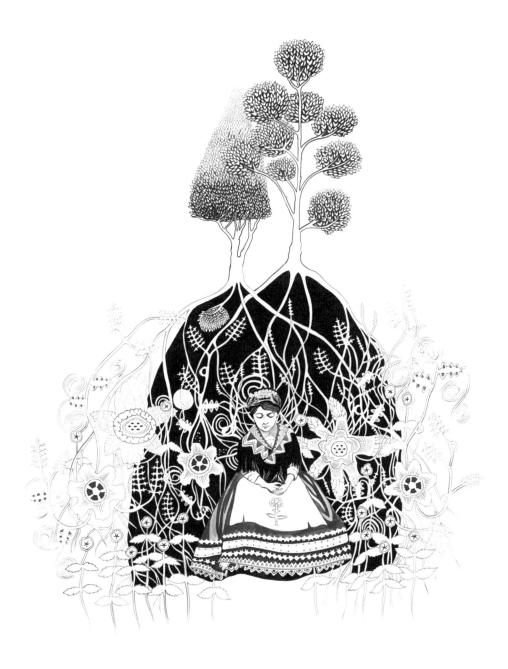

Whose Action is no Stronger than a Flower, 2009
Ink on Stonehenge Paper
15" × 22"

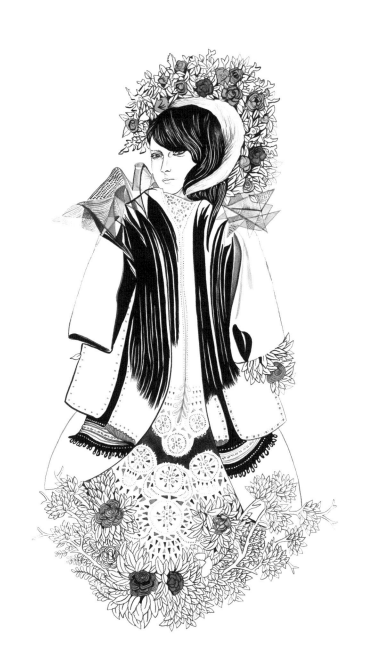

Nereid, 2009
Ink on Stonehenge Paper
15" × 22"

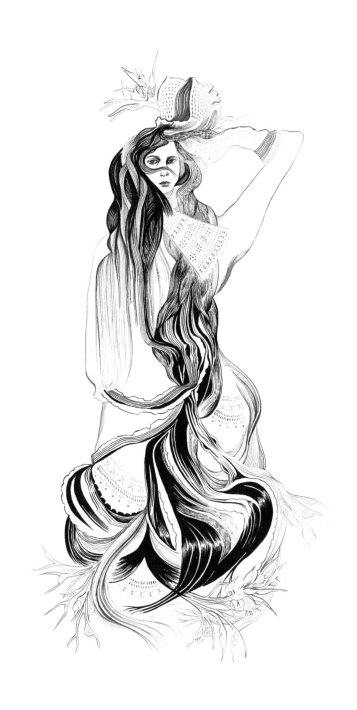

Burrow, 2010
Ink on Stonehenge Paper
15" × 22"

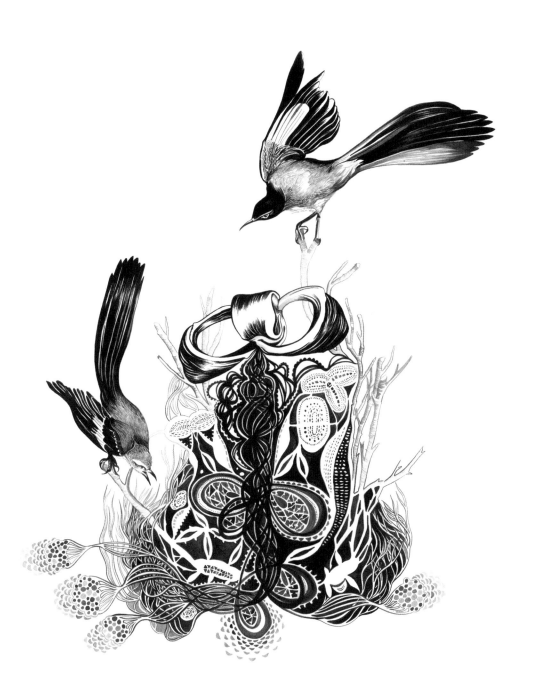

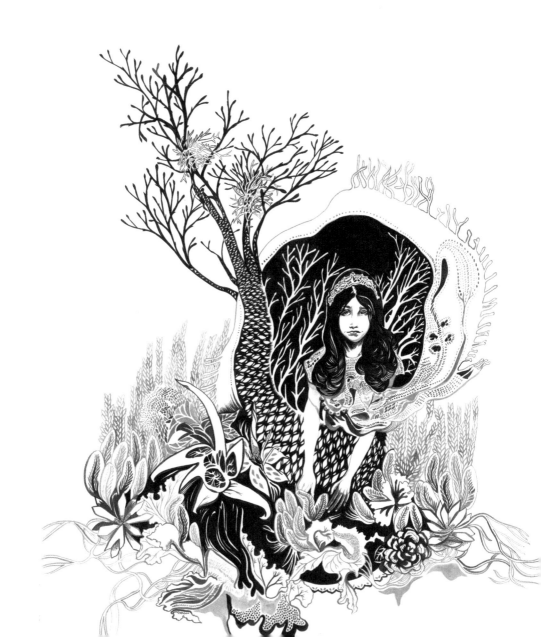

Prelude, 2008
Ink on Stonehenge Paper
22" × 15"

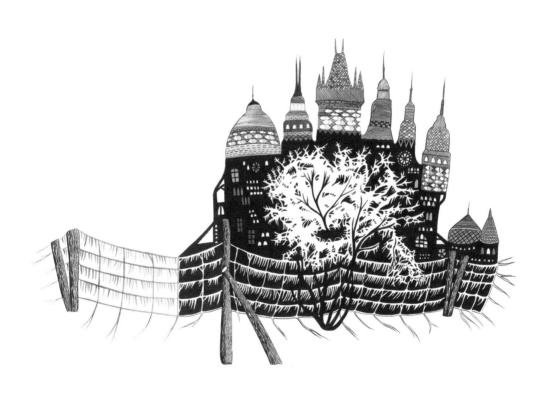

The Difference, 2008
Silkscreen on Stonehenge Paper
11" × 15"

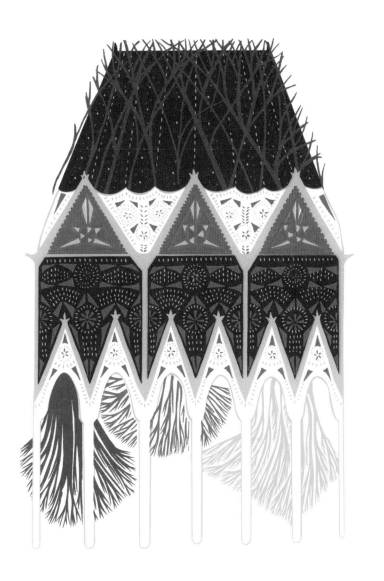

When Only One, 2008
Silkscreen on Stonehenge Paper
14" × 19"

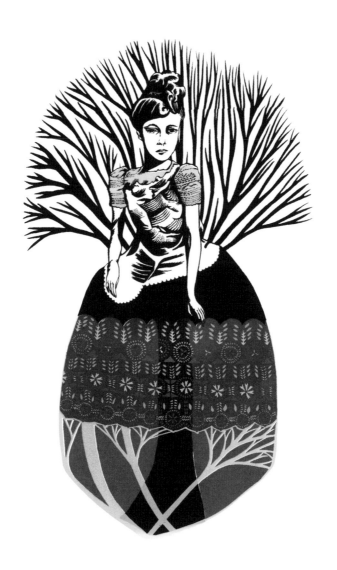

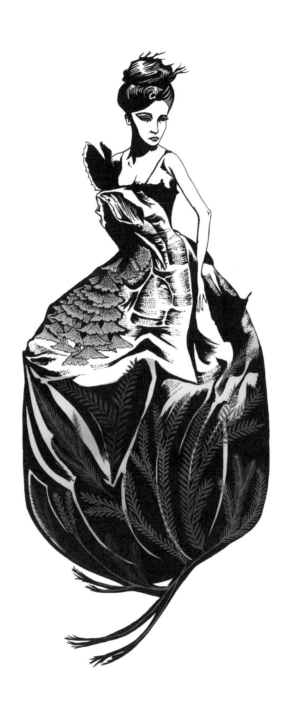

Hide & Seek, 2008
Silkscreen on Stonehenge Paper
15" × 22"

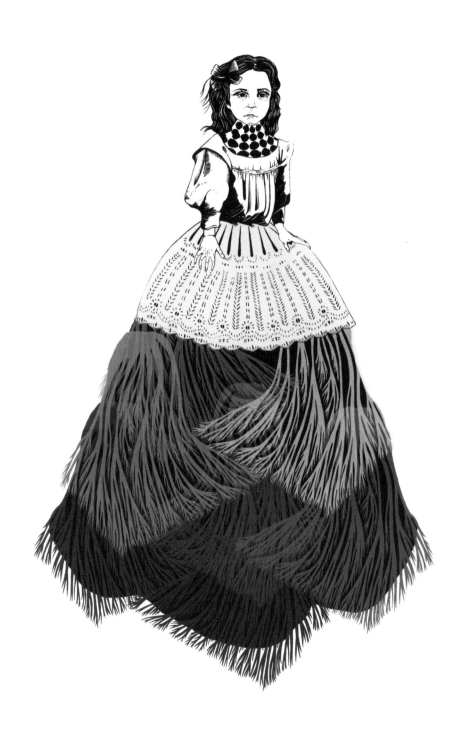

Hidden Lady, 2008
Silkscreen on Stonehenge Paper
15" × 22"

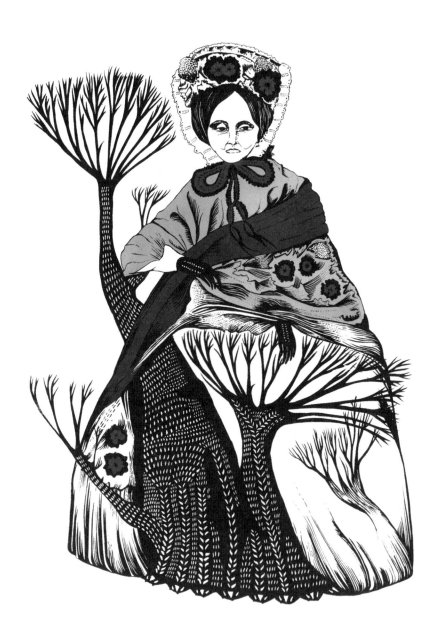

Familiar Spirit, 2008
Silkscreen on Stonehenge Paper
15" × 22"

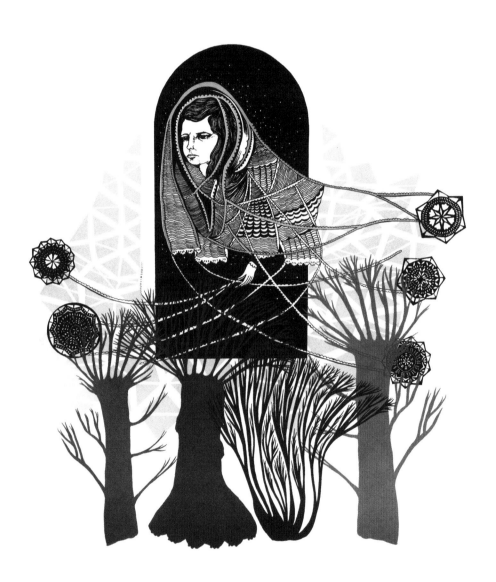

Untitled (Closed Garden), 2010
Ink on Stonehenge Paper
15" × 14"

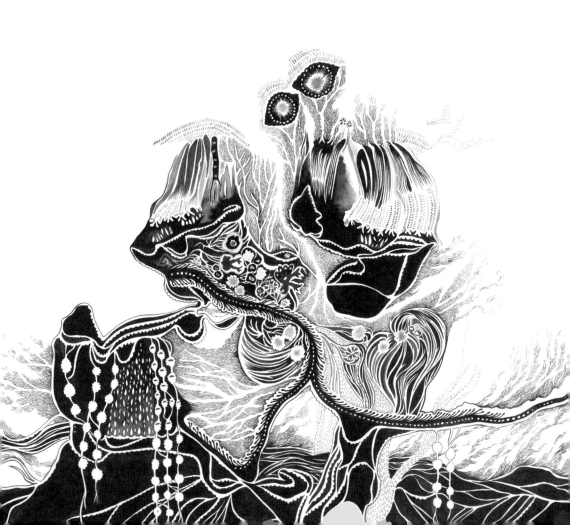

Spirit, Come Back! 2009
Ink on Stonehenge Paper
12" × 15"

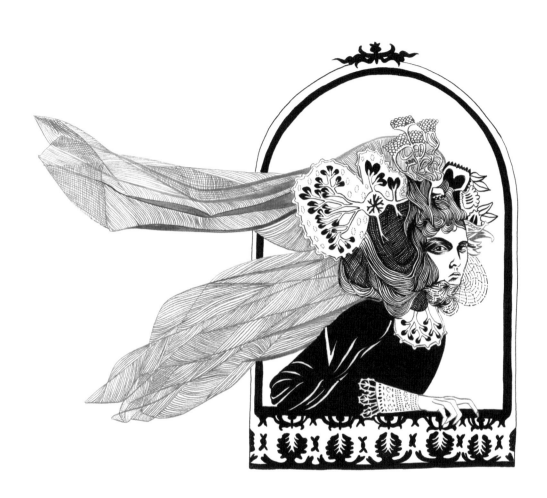

Off Rooftops, 2008
Ink on Stonehenge Paper
15" × 22"

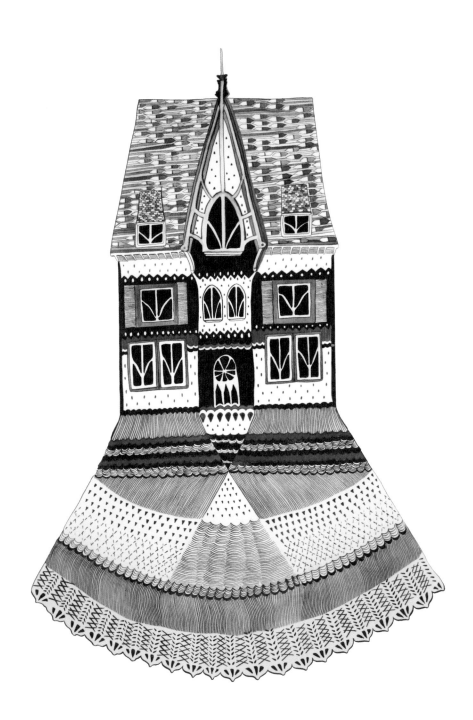

Red Vine, 2010
Ink on Stonehenge Paper
15" × 22"

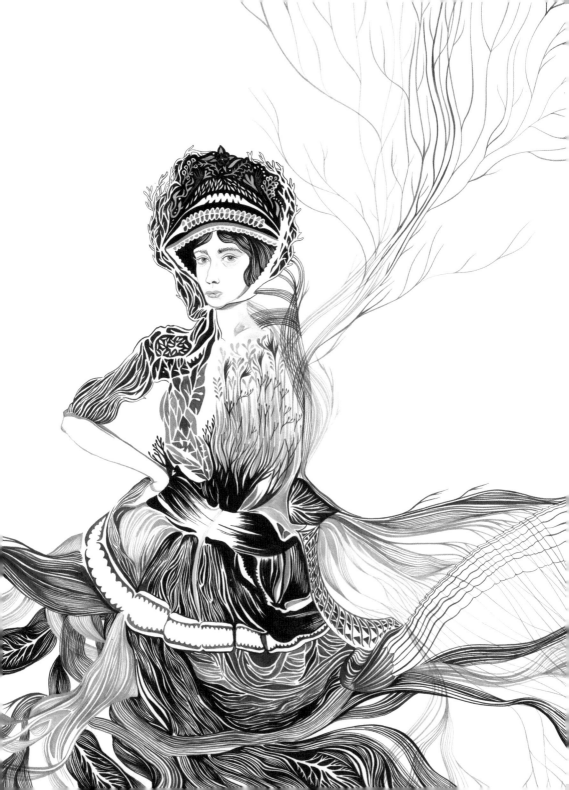

Untitled, 2011
Ink on Watercolour Paper
15" × 21"

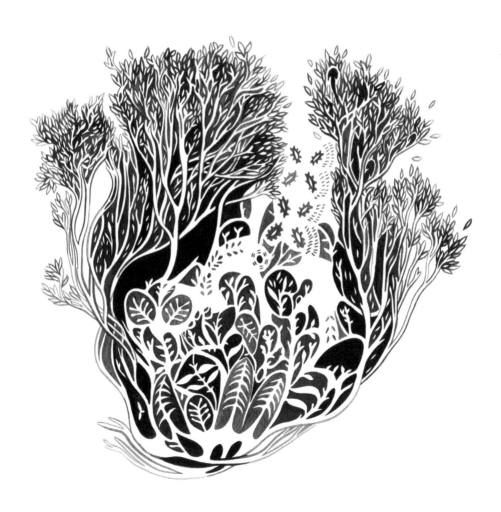

Untitled, 2011
Ink on Watercolour Paper
15"× 21"

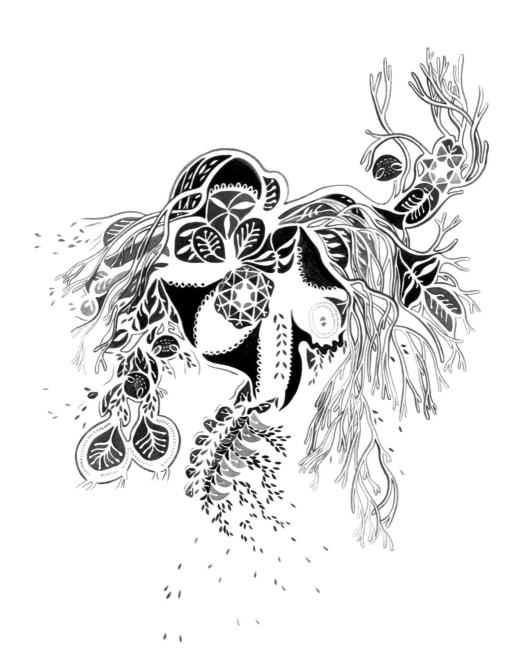

Mint & Willow, 2011
Ink on Stonehenge Paper
18" × 24"

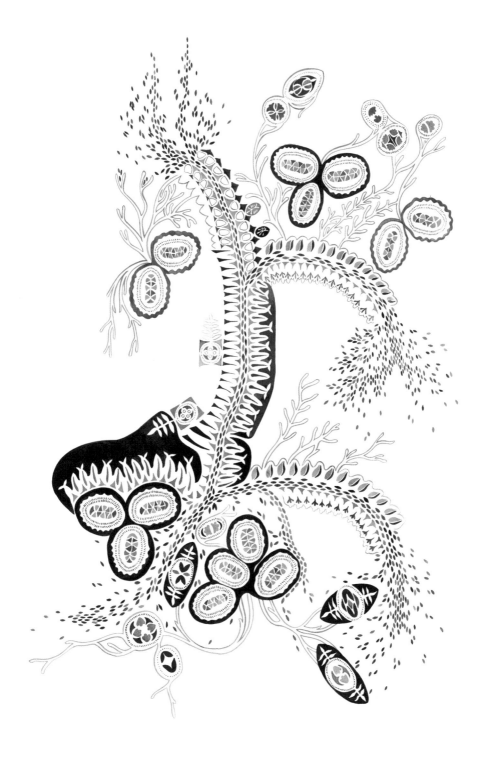

Heath, 2008
Ink on Stonehenge Paper
15" × 22"

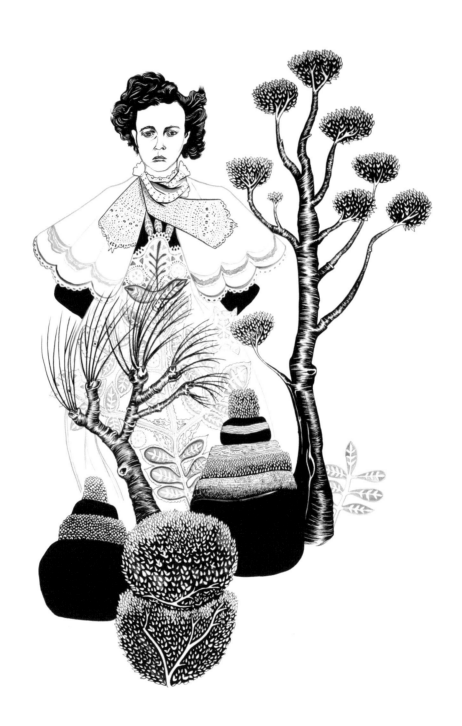

Infinite Green, 2008
Ink on Stonehenge Paper
15" × 22"

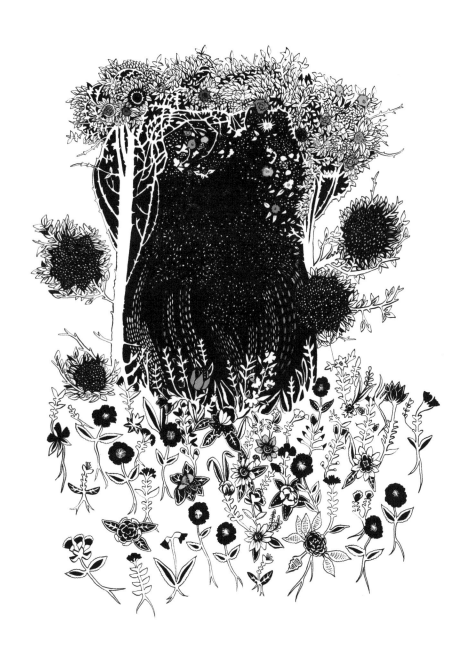

Untitled (Tree), 2011
Ink on Watercolour Paper
11" × 15"

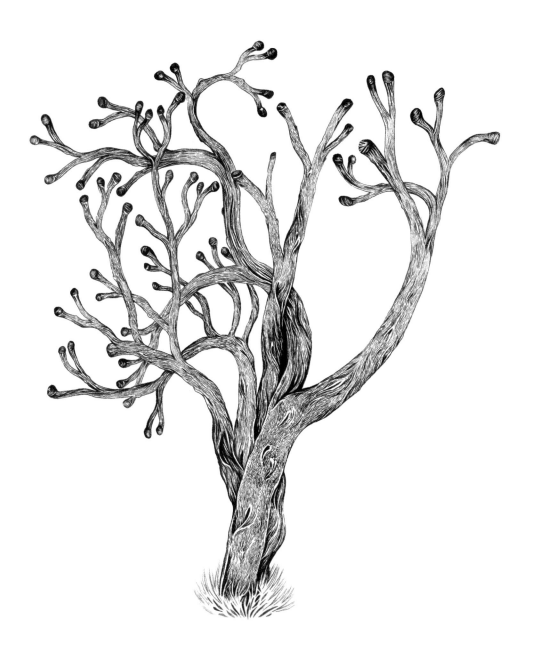

Hotel Homes, 2008
Ink on Stonehenge Paper
15" × 22"

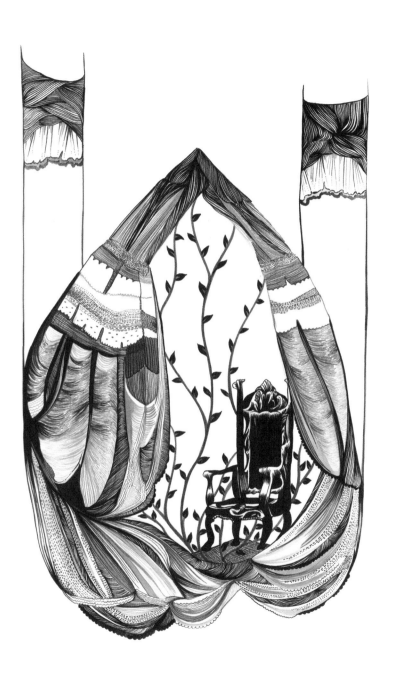

Untitled (Hunched Girl), 2010
Ink on Stonehenge Paper
14" × 15"

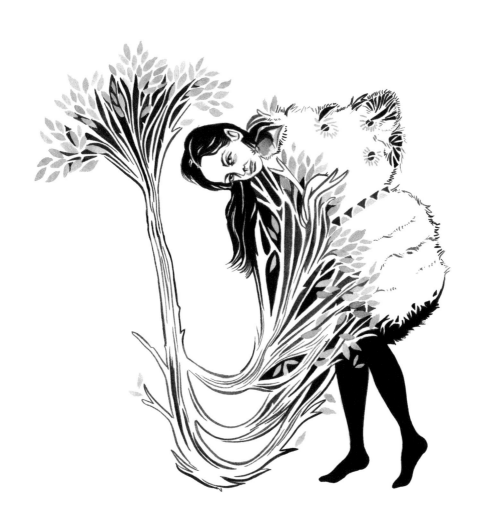

Peer Out Window, 2011
Silkscreen on Maidstone Paper
15" × 22"

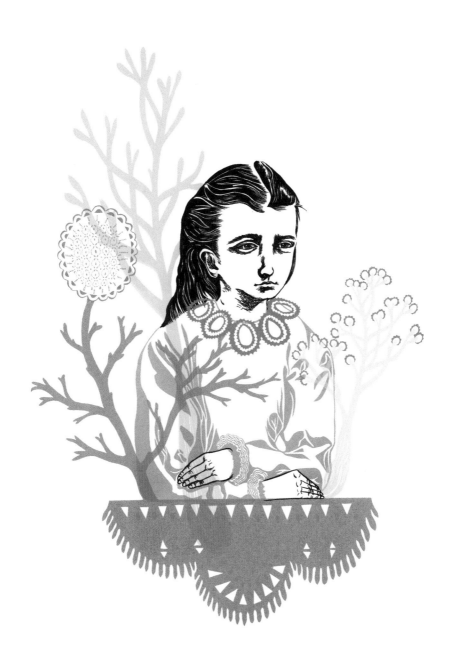

House I, 2006
Silkscreen on Arches Paper
15" × 19"

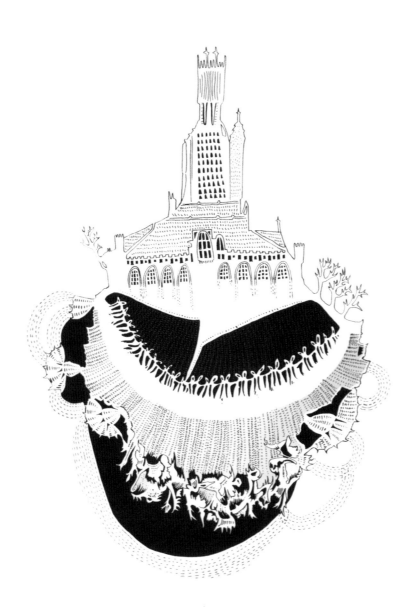

House II, 2006
Silkscreen on Arches Paper
15" × 19"

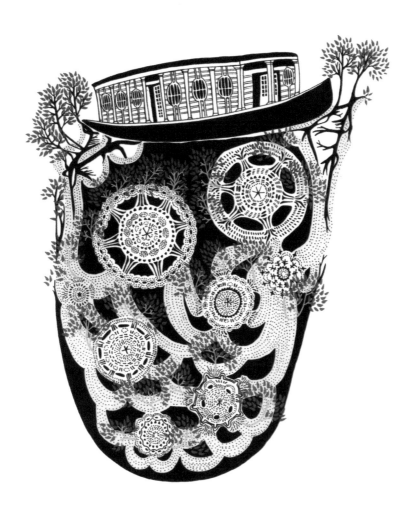

House III, 2006
Silkscreen on Arches Paper
15" × 19"

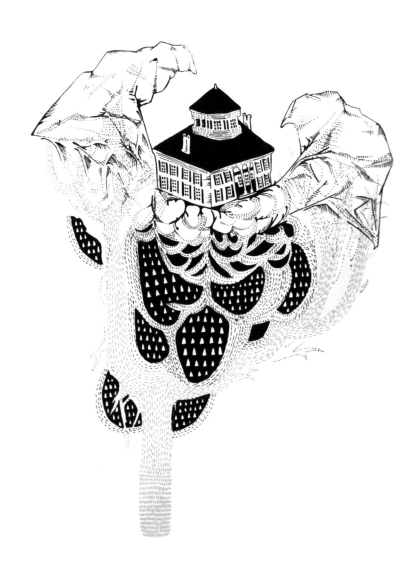

Sofia, 2006
Silkscreen on Stonehenge Paper
7" × 10"

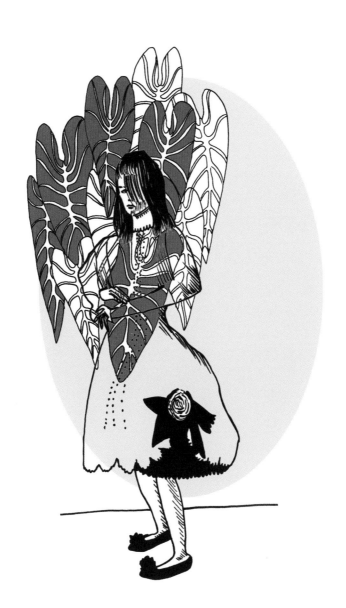

Knoll, 2007
Silkscreen on Stonehenge Paper
11" × 15"

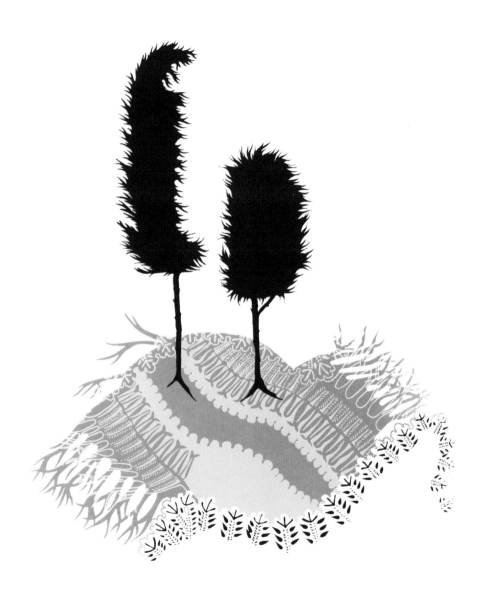

Untitled (Redhead), 2008
Ink on Paper
11" × 15"

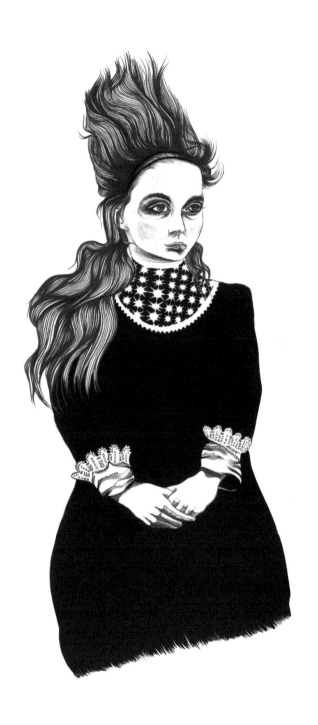

Hanging Garden, 2011
Silkscreen on Maidstone Paper
22" × 30"

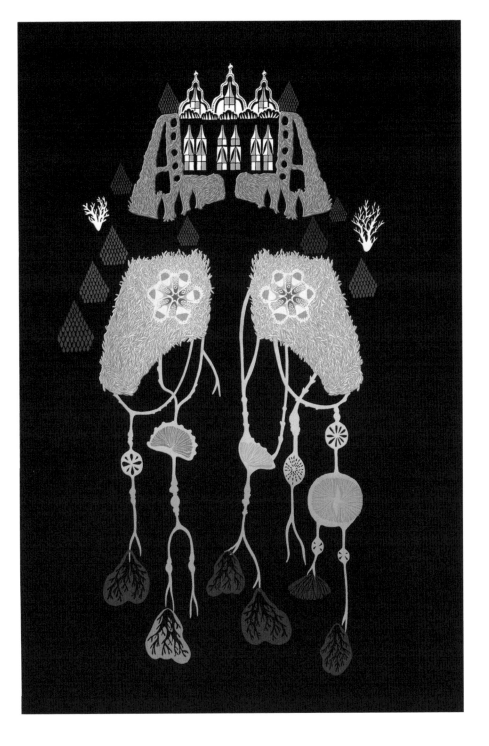

Drawn & Quarterly; Post Office Box 48056; Montreal, Quebec; Canada H2V 4S8; www.drawnandquarterly.com.

First paperback edition: April 2012. 10 9 8 7 6 5 4 3 2 1. Printed in Singapore.

Library and Archives Canada Cataloguing in Publication: Albrecht, Amber, 1981–; *Idyll* / Amber Albrecht; ISBN 978-1-77046-063-8; I. Title. PN6733.A43I39 2011 741.5 C2011-905291-1.

Drawn & Quarterly acknowledges the financial contribution of the Government of Canada through the Canada Book Fund for our publishing activities and for support of this edition.

Distributed in the USA: Farrar, Straus and Giroux; 18 West 18th ST; New York, NY 10011; Orders: 888.330.8477.

Distributed in Canada by: Raincoast Books; 2440 Viking Way; Vancouver, BC V6V 1N2; Orders: 800.663.5714.